THE REX
REWARD SYSTEM

THE REX
REWARD SYSTEM

Rex Romaine Bahr

THE REX REWARD SYSTEM

iUniverse books may be ordered through booksellers or by contacting:

iUniverse
1663 Liberty Drive
Bloomington, IN 47403
www.iuniverse.com
844-349-9409

ISBN: 978-1-6632-2198-8 (sc)
ISBN: 978-1-6632-2199-5 (e)

Print information available on the last page.

iUniverse rev. date: 04/24/2021

THE
 REX
 REWARD
 SYSTEM
 TO
 NEUTRALIZE
 THE
 PENALTY
 SYSTEM
 AND
 THE
 STUPID
 POLITICAL
 SYSTEM

THE REX REWARD SYSTEM

We cannot solve our problems with the same
thinking we used when we created them.
Albert Einstein

All INCOME, and other PENALTY TAXES will be gone.

The income tax has made liars out of more Americans than golf.
<u>Will Rogers</u>

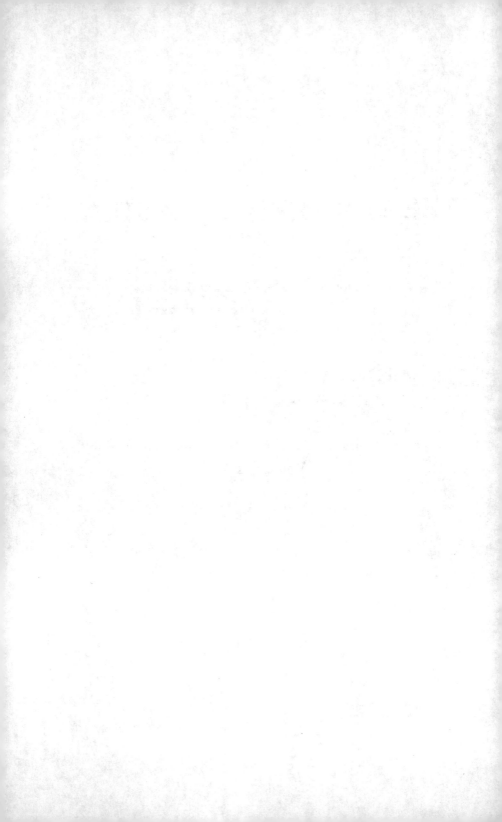

WHY FOR YOU ASK?

No longer will you be PENALIZED for DOING, A JOB, RAISING FOOD, GATHERING GAS, PUMPING OIL, PRODUCING A PRODUCT, BUYING PROPERTY, BUYING A VEHICLE, IMPROVING PROPERTY.

Look at it this way. A farmer takes the grain he raised to market and he is paid for the grain. Now he must pay a PENALTY for all the work and cost he put into the crop. Do you think that is a way to REWARD a person for DOING and to keep a country strong and prosperous?

If this is stolen or messed with in any form, it will be a FEDERAL CRIME, PUNISHABLE WITH DEATH and the same for stealing a person's work machine = HORSE, BICYCLE, VEHICLE, or whatever, like in the days when HORSE THIEVES were hung for stealing the method a person used to

make a living. I was a Cowboy more or less, when I worked for Morris Beal near Hershey Nebraska and we used Horses to do a lot of work. And we used the Airplane to check the cattle, fences and the irrigation water. It was amazing to be able to see the water shine like a mirror when the sun was shining, even through the alfalfa.

When we checked fence Morris would pilot the plane while I watched the shadow of the fence and he flew so low at times the grass would spin the wheels. When I saw the shadow stop, he would pull up and check windmills, smoke and trees to get the direction of the wind then land so we could fix the fence. We then take off to check for cattle out of the pasture and luck was with us as we did not find any. We also used the plane to check cattle that Morris was thinking of buying. This is a picture of a plane exactly as he had, and Mister Morris Beal's was a nineteen forty-six >1946< Aeronca Champ with a six >6< foot aluminum propeller. He offered it to me for $500.oo and if I had a place to keep it I sure would have bought it but Dad had retired off the farm and keeping it at an airport would be expensive and I was headed to the United

States Air Force in November of nineteen fifty three >1953<.

WITH MY REX REWARD SYSTEM EVERY LEGAL CITIZEN OF THE UNITED STATES AND THE WORLD WILL GET A SET SUM WHEN THEY ATTAIN THE AGE OF EIGHTEEN YEARS OF AGE AND IF THEY AGREE TO BE STERILIZED, THEY WILL GET A BONUS ADDED because the world does not need more people. The sterilization will be on what the doctors say.

As most people know, seventy to eighty percent >70-80%< of the People in the United States and the world pay no TAXES. That is, BUSINESS, WELFARE, CASH WORKERS, FOOD CARTS, RELIGION, TOURISTS, BUMS and hundreds of others.

BUSINESSES ARE IN FACT, TAX COLLECTORS OR PUT ANOTHER WAY, DOING THE GOVERNMENTS DIRTY WORK. When a TAX is levied onto a business, the business must get the money to pay the TAX from their customers, therefor the public is in fact being taxed indirectly.

I worked for the Kansas Internal Revenue Service >I. R. S.< in nineteen ninety nine >1999< and I was amazed to see how many FARMERS and RANCHERS made over five million dollars >$5,000,000.oo< and paid no taxes. **You see they need to do a lot of paperwork and have a Church that they can give money too and get a KICKBACK to be able to do that and they need to do that to have money left to buy product or machinery for next year. Now if this is TRUE then we have a PROFIT TAX SYSTEM, NOT AN INCOME TAX SYSTEM. The SYSTEM was setup by White Christians for White Christians and screw the rest.**

The Veteran System will not be like it is today in twenty, twenty >2020< as it is not much good. It would be a contract system. People will be able to go to locations close to them where the medical is in a

system that has a contract with the federal Government to take all VETERANS who apply. The prices will be paid and controlled by the federal Government as all able bodied will be drafted at age eighteen >18< to serve the military or other places where they are needed and is why Champ VA or some other system will be their medical Insurance.

STATES, COUNTIES, TOWNS, OR CITIES WILL NOT BE ALLOWED TO LEVY ANY TAX OR CHARGE OF ANY KIND.

The states will get an allowance according to a legal honest census. I helped do the census at Topeka Kansas for the two thousand >2000< census and for every one of the ones I could count there were five >5< I could not count. They say they are just visiting or was counted before or some excuse. I know they are lying as I see them here all the time when I go shopping and some, I can see from where I live and as I know this is true then there are at least five times as many in the United States than what we are told by the Controllers.

You can't imagine how many times I was met at the door with a GUN in my stomach. I was threatened many times with death if I told anyone where they

were living. Once I told my Lady >? < boss about one and she said OK I will go with you to check on him. We went and she knocked and when he opened the door, he yelled that I TOLD YOU TO NOT TELL ANYONE, I WILL GET YOU! My lady boss told me to go wait in the car, so I did. I do not think she got a thing from the man of who he is or why is he in vacant property.

Of course, no name and some had names with many digits which I think were fake like RUMPELSTILTSKIN! We do not ask for identification of any kind so I would guess there is double or even five >5< times the number of people in the United States according to the official census.

If I were doing the census the first, thing I would use is the Social Security records, then WELFARE and Drivers license and then the addresses missed and I would send out Law Enforcement Officers, known as LEOS as it is dangerous to go where you have not been invited.

Part of the census taking is like this. I married an ILLEGAL RUSSIAN and when we got her Social security number the clerk asked, there is a name here just like yours, is that you? Of course, my wife of a few

days said NO. When we got outside, I told her to start talking. She said everything she has, Social Security card, Drivers Licenses, Green Card is all illegal and we bought them from Cubans in Florida.

The Federal Internal Service that gets the money collected from the TRANSACTION TAX is tasked with giving money to the States according to the legal honest census then the states will allot the money to the counties and the counties or whatever will allot money to the cities as the controllers see fit. The Cities will be encouraged to consolidate with the county or whatever they are called, to cut costs and improve efficiently. Your property tax is gone as well as the PENALTY TAX you must pay if you want a vehicle, even if it is needed for your business or job.

NOW WHERE ARE WE GOING TO GET THE MONEY TO FINANCE THE REX REWARD SYSTEM?

THERE WILL BE A SALES, TRANSACTION CHARGE, TAX ON EVERY TRANSACTION NO MATTER THE SIZE, AND FORGET THE EASY TO GET AROUND PERCENTAGE SYSTEM.

This will start at one Dollar >$1.oo< and go up or down as needed as the system is phased in. The money will be collected by the company or person doing the selling. They will be required to keep records of the sales and the collected money is to be sent to the Internal Revenue Service = I. R. S. These records will be checked from time to time by the I. R. S. and if there is any wrongdoing they will be punished severely and if this happens again, they will be sterilized and assigned to a reservation.

How many SIX >6< PACKS of Beer or SODAS and DRINKS and CANDY, POPCORN, TRANSPORTATIONS, MOVIE, SHOWS, CONCERTS, RIDES, BUS, CARNIVAL, STOCK, GAMBLING CHANCES, RACING ETC. that are sold in a year? Now people are going to scream that this is unfair for the POOR and it is but they will be getting FREE money so they will not have much of a reason to scream.

The FEDERAL I. R. S. as well the STATE I. R. S. has the responsibility to collect the money and to ensure that each LEGAL citizen gets their allotment and it is their responsibility to take a

CENSUS every six >6< years and to oversee that illegal persons are deported.

Each legal citizen will get a set amount when the system is running at one hundred percent >100%<. To start it will be one thousand dollars >$1,000. oo< a month or what is deemed reasonable by the I. R. S. and this will change as needed to maintain a healthy economy. It can be tweaked as we go along to make it work better.

Look at it this way. I get the money and as I buy things, I pay myself and if you buy something you pay yourself. That is when I spend the ALLOWANCE, I have paid myself and if I buy more than my allowance, then I am supporting my fellow man and my country. This more than your allowance is the money you get for working or doing what you do, like farming or some other thing you like to do like collecting aluminum cans etc. for the ten cents >$0.10< you can get now in twenty, twenty >2020< in Oregoon of the United States.

The United States Government figures roughly that for every dollar >$1.00< they give out they will get about Five dollars >$5.00< in taxes returned to the I.R. S. and this is the TRICKLE-DOWN

THEORY. Say a company pays their worker with Five Dollars >$5.00< and if the worker does not have a business to deduct the five dollars >$5.00< it is taxed. Now the worker buys something with the five dollars >$5.00< and the company pays an employee that does not have a way to deduct the five dollars >$5.00< it is taxed again, and again, and again till it is gone with the system that the United States has now in twenty, Twenty >2020<.

Now look, with the REX REWARD SYSTEM when a company buys things to produce something, they will pay their employees, the owners and stockholders and others indirectly and out of their control. NOW LET THAT SOAK IN.

Now since the employees are getting money from the I. R. S. they can work for much less, therefor less overhead for the company and less overhead, means they can sell their product or service for less. This being so the employees can pick and chose their employers as they have an income other than what they get for working.

People do not need to lie nor work for ca$h with the REX REWARD system in full swing. In a sense every LEGAL CITIZEN will be on WELFARE

so to speak. They do not need to work if they do not want to, but when they work they can build up a nice nest egg for their heirs and or other people they like to take care of, and or donate to people doing good things all over the world, like DOCTORS WITHOUT BORDERS.

Inventions will be much easier to get patents for and they will not co$t anything.

I have patents 6446422 and 10525174 and they co$t about Thirty Thousand dollars each and it takes way too long, like twenty >20< years to get a patent and my patents are not sold. STUPID AT BEST, DO YOU THINK?

Along this line to get the REX REWARD SYSTEM working all WELFARE, AND BUMS will be sterilized and assigned to a reservation like the other UNDESIRABLES. The reservations will have care takers and there will be plenty of housing furnished. They will be trained to do ALL the work that is needed. Their allowance will be used to run the reservation as to food, medical, education, supplies and all the other things needed to run the reservation, healthy and safe. The reservation will have machinery and horses to farm with plus cattle

for milk and meat and hogs for meat and to feed the waste to. Sanitation is always a big problem so that will take up a lot of the automatic funds the people will get. The people on the reservations will be required to work to keep the reservation going or they will get mighty hungry.

Some may want to attend training to leave the reservations to get work as positions will posted in the game halls.

PRISONERS will also get the allowance and their allowance will be used to run the prison, but everyone getting an allowance I do not expect much criminology. These RESERVATIONS will be administered by the INTERNAL REVENUE SERVICE.

People will think this is harsh and I agree, it is, but it must come to this if you expect the human race to survive in a healthy state. It is much closer to DISASTER than most realize.

The reason for this is how things are and the Bums and Welfare are making life hard for the ones that work or have an income by their stealing and vandalizing. If the BUMS keep stealing, they will be hung in the town square if found guilty. Technology

has made it that there is less need for employees and as long as there is an excess of people it will be this way till the end of the human race if something is not done like I propose.

Say a company pays for what is needed for the company, product, employees, utilities. As all taxes, will be gone the company DOES have to pay the transaction tax but not having other Taxes to pay the company has better control of the future of the company. That is; it is no longer under the thumb of PENALTY TAX SYSTEM and local crooks. This being so it must bring in enough money to pay the employees and buy the products that is needed to make what it sells and pay the TRANSACTION TAX and make enough to maintain and expand or upgrade.

The TRANSACTION charge needs to be decided if it is to be applied to Utilities, food, medicine and medical appointments.

The REX REWARD SYSTEM will release COMPANIES, FARMERS, RANCHERS and OTHERS from mounds of paperwork to pay TAXES or to avoid TAXES. Just that LITTLE fact will save a few hundred trees. The REX REWARD SYSTEM will encourage companies large or small to buy and

13

store more to keep the number of purchases lower, and fewer trucks delivering trips. The tax or fee will be on each individual item by product not containers. Like a case of twenty >24< of one type of SODA in figured as the item but if it is broken down per six >6< pack and bought and sold as an item then the charge will be figured on the six >6< packs. So, you see the companies will be doing what they have been doing all along, breaking the purchase down to smaller units to sell at a good profit. As this is so, the I.R.S. = country will be getting money to help the people of the country or the world after we get a one world government.

The federal governments of the world will be required to build more railroads and to buy the latest trains for the system.

Say a person is fueling up their vehicle so it is to their advantage to fill up as the charge is on the purchase, TRANSACTION, not on how much they buy, so they need to avoid buying often as much as possible and running this through your brain you should see that companies will do the same thing, cutting down on trucks and trains hauling things.

At the Horse racetrack there is a charge per ticket, not that you came just once, and this applies

to all types of programs as there will be no charge to get in because to me a charge to get in is a form of DISCRIMINATION. That is, it discriminates between the rich and the poor. A movie at the movie house is FREE and the business will have to make their income on product they sell so POPCORN is going to be expensive and the Movie theater must collect the transaction tax.

As each person connected to the theater will be getting the ALLOWANCE, they will have money to spend even if the theater barely breaks even.

EACH PERSON WILL PAY THE TAX PER ITEM WHEN THEY PURCHASE IT.

The REX REWARD SYSTEM causes everyone that buys will help pay the Post Office and the money hungry bad WELFARE SYSTEM and other Government programs like POLITICIANS.

The companies that sell will have to keep records, so they know how much tax to pay and for the Internal Revenue Service to check from time to time.

Now if you are up with me you will now know how the REX REWARD SYSTEM has concentrated the tax system down to Businesses only, cutting millions out of the PENALTY SYSTEM. THAT

IS, only business or people that SELL must collect the tax whereas the purchaser pays the tax and it is done, none of the end of year stupidity.

Businesses will not have to shell out so much money for workers as they have an income and now all the company needs to do is pay enough to get good help as the employees Social Security and Medical is paid by the Internal Revenue System. The company will have benefits like life Insurance or other programs to help them get good employees.

The REX REWARD SYSTEM is to try to make the economy more equal as Abraham Lincoln was wrong when he said all men are created equal and if you live long enough you will learn how much this applies.

The simple REX REWARD SYSTEM will allow people to save and budget without inference of the Federal Government. This is great if the savings are paying a good interest and you won't age so fast and probably will have better health not worrying about TAXES and the very bad WHITE AMERICAN CHRISTIAN PENALTY TAX SYSTEM.

The REX REWARD SYSTEM should stop most petty crimes, make it almost impossible to scam people,

mainly the ill-informed and the elderly and all will be able to find a place to live or the CONTROLLERS need to step in and fix the problem with HARSH MEANINGFUL PUNISHMENT if anyone steps out of line to rob and or scam people.

Rent control is not needed but cheap housing is. I have written to Senator of Kansas Robert >Bob< Dole long ago asking him to get the government to build a factory at the PINE RIDGE RESERVATION to build winter type trailer houses, but he did not answer. This needs to be done so there is cheap housing and as such there needs to be a way to destroy these and replace them as they get a few years on them, so Plastic can be used as it can be recycled.

The problem of what the United States has now is Robots do most of the work and companies will spend a fortune to do away with humans as Humans is the problem. Humans work harder to get out of work than if they just went ahead and did the work. Humans have medical problems and they like to SUE at the drop of their hat, and I will guess that companies will hire more than what they need to help alleviate the problems.

It gets confusing and I am not smart enough to figure out what needs to be done like how to charge the pipelines and other large wholesale transactions. I assume this would be handled by and through the system of how the product is measured. I encourage the people that help get this set up that they avoid PERCENTAGE AT ALL COSTS as percentage is too easy to get around to avoid taxation.

To start it would be one Dollar >$1.00< a transaction to get the system working and push the PENALTY SYSTEM out and then go up or down from there as needed.

Say if there was a dollar charge per transaction then just the money from Las Vegas would be in the billions and the Government would have to figure out what to do about the Native Reservations and their gambling. I would assume a reservation would be treated like a STATE and the people would pay the tax and get the allowance per person over the age of eighteen >18< and the cities or town on the Reservation would be treated just like any state in the United States.

>>>>>>>>>>>>>>>>> COPY <<<<<<<<<<<<<<<<<

Published by <u>Liam O'Connell</u>, Jan 27, 2020
This statistic shows the number of convenience store transactions per week in the United States from 2017 to 2018, broken down by format. In 2018, there were 3,244 weekly in-store transactions in convenience stores in the United States. There were 2,327 motor fuel transactions per week in the c-store channel that yea.

U.S. Department of Labor

Wage & Hour Division
Washington D.C. 20210 April 6, 2018 (<u>PDF</u>)

MEMORANDUM FOR:

Regional Administrators
Deputy Regional Administrators
Directors of Enforcement
District Directors

FROM:

Bryan L. Jarrett
Acting Administrator

Rex Romaine Bahr

SUBJECT:

Amendment to FLSA Section 3(m) Included in Consolidated Appropriations Act, 2018

This Field Assistance Bulletin (FAB) provides guidance concerning the Wage and Hour Division's (WHD) enforcement of tip credit rules under the Fair Labor Standards Act (FLSA) after Congress amended the FLSA in the Consolidated Appropriations Act, 2018 (Act), Pub. L. No. 115-141, Div. S., Tit. XII, § 1201. The Act prohibits employers from keeping tips received by their employees, regardless whether the employer takes a tip credit under 29 U.S.C. § 203(m). The Act also provides that portions of WHD's regulations codified at 29 C.F.R. §§ 531.52, 531.54, and 531.59 that barred tip pooling when employers pay tipped employees at least the full FLSA minimum wage and do not claim a tip credit shall have no further force or effect (until any future action by the WHD Administrator). 1 WHD expects to proceed with rulemaking in the near future to fully address the impact of the 2018 amendments. 2

In the meantime, given these developments, employers who pay the full FLSA minimum wage are no longer prohibited from allowing employees who are not customarily and regularly tipped—such as cooks and dishwashers—to participate in tip pools. The Act prohibits managers and supervisors from participating in tip pools, however, as the Act equates such participation with the employer's keeping the tips. 3 As an

enforcement policy, WHD will use the duties test at 29 C.F.R. § 541.100(a)(2)-(4) to determine whether an employee is a manager or supervisor for purposes of section 3(m).

The Act also provides enforcement authority in FLSA sections 16(b) and 16(c) to, among other things, recover all tips unlawfully kept by the employer, in addition to an equal amount in liquidated damages. The Act further provides WHD with discretion to impose civil money penalties (CMPs) not to exceed $1,100 when employers unlawfully keep employee tips. In assessing CMPs, WHD will follow its normal procedures, including by determining whether the violation is repeated or willful.

Finally, given the above developments, WHD's July 20, 2017 non-enforcement policy concerning retention of tips by tipped employees paid the full FLSA minimum wage will not apply to new investigations beginning on or after March 23, 2018. When an investigation covers periods before and after March 23, 2018, and the employee was paid at least the full FLSA minimum wage, violations of section 3(m) may only be cited if they occurred after March 23, 2018.

>>>>>>>>>>>>>>>>>>>>> END COPY <<<<<<<<<<<<<<<<<<<<<<

With the REX REWARD SYSTEM, we would NOT have all the trouble we have now in early of twenty, twenty >2020< from the COVID-19 Virus

as the people would be getting their allowance and hopefully a good savings account, so the STIMULUS money would not be needed. The workers would lose their work income, but the ALLOWANCE will keep going.

With the REX REWARD SYSTEM all people would pay something so it would not be a burden on the ones who work for a payday. The people on WELFARE and the BUMS will get the allowance and sterilized and placed on the reservation so they are not a problem draining the money out of the IRS because of the crime of WELFARE.

Welfare and other programs that are state administered and federally funded will come to a halt. No longer will the federal government be dolling out money for programs. The states will use the allowance they get to run things how they see fit with very little oversight from the federal government. The states are not allowed to levy any tax of any sort.

Robots would pay indirectly when they are bought, serviced and repaired and when the product they helped make is sold will pay a tax. The main burden is for the business that sell a product or service having to collect

and keep records, but they have been doing this for years so not much change there, and the beauty of the REX REWARD SYSTEM is it gets away from all the dumb people paying people to figure their taxes. I will guess it will make a lot of people very happy.

The lotteries will be topped at five million dollars >$5,000,000.oo< and when it goes over there will be additional numbers pulled. Years ago, this lottery scam was called THE NUMBERS RACKET by the MOB.

The .99 will be gone as this and other stupid things slow the computers. I suggest that prices be held at the dollar to help the computers do their thing and if not that then at least at fifty cents!

The Rioters in May and June 2020 about George Floyd being killed by a White Law Enforcer Officer >LEO<, has caused a lot of damage. A lot of companies, meaning CONTROLLERS will just call it quits and do other things to get by till DEATH or even SUICIDE.

THE FOOD PROBLEM

The FOOD SYSTEM in the United States now in two thousand and twenty >2020< teeters on the brink of collapse. Now it is not going to collapse and not produce food, but what is going to happen is the rate of IMPROVEMENT is going to slow to a snail's Pace and the POPULATION EXPLODES LIKE AN ORGASM the food production cannot produce what is needed. This is when humans and some animals will start dying by the hundreds and will make the COVID-19 VIRUS look like a MINOR problem. >>>

COPY

Agriculture has always been at the mercy of unpredictable weather, but a rapidly changing climate is making agriculture an even more vulnerable enterprise. In some regions, warmer temperatures may

increase crop yields. The overall impact of climate change on agriculture, however, is expected to be negative—reducing food supplies and raising food prices.[7] Many regions already suffering from high rates of hunger and <u>food insecurity</u>, including parts of sub-Saharan Africa and South Asia, are predicted to experience the greatest declines in food production.[7–9] Elevated levels of atmospheric carbon dioxide (CO_2) are also expected to lower levels of zinc, iron, and other important nutrients in crops.[10]

END COPY

WE DO OUR BEST BUT SAD TO SAY THAT SOON WILL NOT BE GOOD ENOUGH. I thought about this TWIN ROW PLANTING many winters ago and I think it would do much better if we planted the Corn in furrows with a LISTER like we did when I was a child in the nineteen fifties >1950s<. This way when we cultivate and move the dirt into the furrow it would give a place for the higher roots to take hold of the ground.

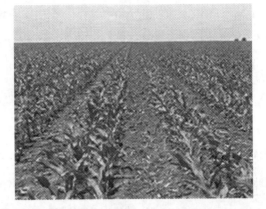

TWIN CORN ROWS to increase production.

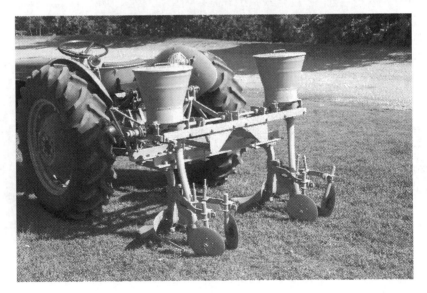

A TWO >2< ROW LISTER

We use a LISTER to plant the crop below ground level and we try to keep it, so the wind blows across the lister rows instead of up or down them.

Now what do you propose we do about food being VERY EXPENSIVE where only the Rich will be able to buy food? This will happen as the system cannot improve food production much more than it is now in TWENTY, TWENTY >2020<.The only ANSWER is to have strict birth control.

The REX REWARD SYSTEM gives people money that they did not earn to buy food and other necessities. Most of these problems have come about because of SO CALLED INCOME TAXES and companies doing all they can to survive and make enough to hire help and improve the company and avoid paying taxes and too many people. Some sell to other countries or get other countries involved to help with cot. It gets to the point of why bother of trying to stay in business when we are super rich! A lot of companies do this by scamming the STOCK MARKET by starting a company and bring in a lot of money then go out of business or sell it and retire. With the REX REWARD system that is going to come to a screeching HALT. There will be new laws that every company that sells stock has to set aside a certain amount per the number of shares they

issued that is to be refunded to the purchaser's if the company goes broke and or drops out of the market.

Here is a fer instance. I bought some shares of a company called ENERGY EXCHANGE symbol EEX and it was one dollar >$1.oo< a share, in two months it was three Dollars >$3.oo< a share. I called my broker and put in a sell order of two dollars >$2.oo< a share when it started falling like a rock. Too bad I was so poor and could not afford more shares as I made one hundred percent on the stock. The next week the company dropped out of the Stock Market. My Brokers said it was an OK stock because it was listed on the New York Exchange. You see; SO, WHAT the company got rich and they are what I call LEGAL CROOKS. You see the System from the very beginning was setup by White Christians for WHITE CHRISTIANS and is designed to get the PEEONS money, one way or another. The rich donate a lot of money and get a fifty percent kickback. This assures the Church will get money and the person donating gets rich by using the constitution. This is the way the Muslims or other people will take over the United States.

To counter the FOOD problem the population needs to be controlled and this will come down to sterilization voluntary and in some cases mandatory. This sounds harsh and shades of the NAZIS and that is true, but this must happen if humans are to survive. There are millions of so-called homeless Bums in every city now in twenty, twenty >2020<. The main problem is food and OIL as farm machinery does not run on wind or sunshine. We can always go back to horses when they reproduce enough so there is enough to farm and that will take many years. When my Father retired from the farm, he was very sad to see the horses sell as they were bought by a buyer for the Horse packing house which was in North Platte Nebraska. Most of the stores in the nineteen fifties >1950s< had Horse meat.

REMEMBER THIS> WHO RUNS OUT OF OIL LAST WINS.

I write CONTROLLERS to stop drilling and use our MONEY to buy the oil we need to let the others lose. The way it is now in twenty, twenty >2020< is Russia would win as they have problems getting their oil to market other than what they need. They attacked Afghanistan to get a WARM WATER PORT and

the Dumb Controllers of the United States went over and screwed everything up. We got Russian out but created others that wanted to convert us all to ISLAM or die, that is our choice. I wonder why Russian did not buy a RIGHT OF WAY through Afghanistan and Pakistan for a pipeline, Railroad and a nice four >4< lane highway. I am fairly sure the people of those countries would like Russia, especially if they get some of the OIL.

EDUCATION

Education will be FREE for most if they want an education, but it will not be mandatory, but they will be drafted into service to their country when they are eighteen years of age and in stable mind and health, for a term of four >4< years or less depending on the need and their ability to perform what is needed. When drafted they may be able to choose a Federally run, controlled school if they are really smart and willing to learn. This will be sort of like WEST POINT, THE NAVAL ACADEMY AND THE AIR FORCE ACADEMY. When they graduate, they will be required to join the military that the MAJOR CONTROLLERS CONTROL. They will start getting the ALLOWANCE at eighteen >18< so that will be used to pay for their schooling. They will be taught a lot of what they want to do if it is practical at the time. They will learn that the country

comes first no matter what. They will be required to go where they are needed and if there is not much of a need, they will be able to put in where they would like to go. This includes the Peace corps, Doctors without Borders and of course the Military and they have to be aware they may be required to stay longer if they are needed. This in effect is most of their education and they can go back to school after the SERVICE TO YOUR COUNTRY = S. T. Y. C. for a limited time as we do not need nor want PROFESSIONAL STUDENTS and they can work where a company needs them and if they do not like that they will be STERILIZED then put on a reservation and their allowance will be to run the reservation.

COPY

Actress Lori Loughlin has pleaded guilty to conspiracy charges in connection with her effort to get her two daughters into college through fraud.

<u>Loughlin</u> and her husband, fashion designer Mossimo Giannulli, sought to get their children into the University of Southern California as athletic

recruits, according to a <u>news release</u> from the U.S. Attorney's Office for the District of Massachusetts.

END COPY

Years past California was awash, full of PROFESSIONAL STUDENTS, going to school on California's free education system or the G. I. Bill. Governor Reagan put a stop, or at least lowered the numbers somewhat by passing a law that higher education will no longer be free. This slowed it a lot but there still were huge problems and there are still a lot of problems of all sorts in UNITED STATES OF CALIFORNIA. With the REX REWARD SYSTEM education will be free and the students can choose if they would prefer to learn a trade instead of an almost worthless degree. **They will be allotted so much time and if they do not graduate within that time their allowance will be cut off. The way it is now in twenty, twenty >2020< and has been for many years, ninety percent >90%< of the education is never used.**

There will be at least two >2< TRADE SCHOOLS in every state and some states may want more to make

them easier to get too. The schools will be connected to companies that hire workers that the school trains for that trade. I worked as a Jet Aircraft Mechanic and after the Air Force I worked for the DuPont company making cellophane. Now I ask you what type of education does the United States Provide now that would have gotten me up to speed for those jobs?

The students can ask for what they want but they will also be encouraged to learn other trades that are in high demand. That is; If they are learning Welding, they may also learn some air Conditioning so they can do many things. The student may also be assigned to learn a trade of what is needed to sustain THE HUMAN RACE.

If I were running the military, I would have the military build factories and train people in the countries where we are fighting to build light Aircraft and other fun things to give the people something to do and I hope enjoy.

I have not been to school above a little of the eight >8ᵗʰ< grade as my Father said he could not afford to send me to school. This is because he needs to rent a place in Spalding as we live over seven >7< miles from town. My other Brother and Sisters would bring the

schoolwork home for me to do and they would take it back the next day, so I did not go to school much the last year. Dad said he sent the Girls and they did not amount to much and I sent Lyle and he dropped out and was in trouble with the principle. I ended up working for International Harvester rebuilding farm equipment when I would be in High school. I learned you do not use a power wire brush to clean aluminum Pistons as it wears the Metal away. One of the men there broke a piston ring and showed me how to use it to clean the groves where the piston rings go. I guess what I did, did not do too much harm as the engine started right up and when it cooled down, we tested the compression and all four >4< cylinders were right up where they should be.

My feeble mind notices that HUMANITY IS RUSHING TO DESTRUCTION. Our United States President now in two thousand and eighteen >2018< is pushing for more oil pumping which to me is a big mistake. Remember this, WHO RUNS OUT OF OIL LAST WINS and what do you think is going to happen when the oil runs out? I can assure you the big farm equipment does not run on sunshine or the wind. Even using my REX engine that can run

on many different types of fuel will eventually be no good as all fuels will be in very short small supply and very expensive.

What needs to be done now before ONE WORLD GOVERNMENT.

As we vote for people to represent us there is no reason whatsoever that we need to vote for President.

With the REX REWARD SYSTEM, it will be like this.

We vote for people to represent us so why not trust them to do the right thing!

To START, the SENATE will nominate two >2< to run for President. Then the full Senate and House will vote for President. The one with the most votes will be the new President and the runner up will be the new Vice-president. This is for the four >4< year term. From then on, the SENATE will nominate two >2< to run for VICE-PRESIDENT. The one with the must votes will move into the Vice-president slot and the Vice-President will move up to President and the President will be out the door. This is to go on till a better worldwide system is found.

This is sort of like O.J.T. On the Job Training. Also, these people will be in the high offices for a total of eight >8< years. No longer will we have the puff and power of radical change of the CONTROLLERS.

I suggest that they be required to stop being associated with a party and work to keep the United States as a country that treats every one of our country the same.

I also suggest that WE, THEY AND THEM change to a three >3< person office of controllers. This will be like the WORLD GOVERNMENT SYSTEM where there is five >5< in the MAJOR CONTROLLERS POSITION.

With an election ever three years, a MAJOR CONTROLLER of a country would be a MAJOR CONTROLLER of that country for nine >9< years.

ONE WORLD GOVERNMENT

ONE WORLD GOVERNMENT
is to work like this.

Each country is to submit a person to represent that country to the ONE WORLD GOVERNMENT which will start in the United States and move from country to country according to the economy of each country of the WORLD. These people would be like a PRIME MINISTER of today and may change over time as things change. Now in twenty, twenty >2020< it would start in the United States like the UNITED NATIONS of today and the UNITED STATES would be the host country for FIFTEEN >15< years then move to China and on down till it has been to FOUR >4< countries then go back to the United States to start over. All countries are encouraged to

consolidate so they have a better economy, and this may cause another country to be a HOST country.

I suggest that ever fifteen >15< years this be reconsidered to be for more or less countries.

The O. W. G. people and in the United States that will be the SENATE, will submit two >2< people then the body and again in the United States that would be the full house would vote for a person to take a position in the five >5< person system to keep Dictators out of business. The one with the most votes would be CONTROLLER NUMBER five >5< and do this over and over till there are FIVE >5< CONTROLLERS.

After the SYSTEM is set up it will operate like this.

In THREE >3< years the three >3< MINOR CONTROLLERS of each country will again SUBMIT a person to run for MAJOR CONTROLLER. Then a group in each country created by votes from the populace and this would be like the ELECTORAL CONGRESS OF THE UNITED STATES and these people would vote to select a person out of the group of the total of all countries that was submitted to move into position five >5< of the major controllers

and the one with the most votes will move to position five >5< of the major controllers. This will push the major controller in position one >1< out of office. So, the person in position one >1< will only be in office three >3< years and number two >2< would be in for six >6< years and number three >3< for nine >9< years and number four >4< for twelve >12< years and number five >5< will be the first one to serve the normal fifteen >15< years. From then on MAJOR CONTROLLERS will move up to position one >1< and out by the same method and they will be a major controller for fifteen >15< years then out and it will be like this till the end of the human race.

US ELECTORAL CONGRESS

Established in Article II, Section 1 of the U.S. Constitution, the Electoral College is the formal body which elects the President and <u>Vice President of the United States</u>. Each state has as many "electors" in the Electoral College as it has **Representatives and Senators in the United States Congress,** and the District of Columbia has three electors.

After FIFTEEN >15< YEARS the one that was in NUMBER ONE >1< Position will be out the gate and the person in number five >5< position will be the first to stay the fifteen >15< years. As you can see, when this is going as setup all the MAJOR CONTROLLERS will spend FIFTEEN >15< YEARS in a MAJOR CONTROLLER POSITION and move up towards position one >1< then out the gate. The major controllers will have the power to control a major military and act

like the SUPREME COURT of cases submitted to them by the Minor Controllers of the countries and not much else, and like I said the country that the person in number one >1< position represents is to furnish a nice place for the five Major Controllers to meet in once a year.

It would be possible that there could be more than one MAJOR CONTROLLER from the same country, but I would hold this at no more than two >2<. That is; if there are two >2< from one country, that country would not be able to submit a person to run for MAJOR CONTROLLER. Sadly; that country cannot submit a person for fifteen >15< years till one of the two >2< is out the gate.

Each country will be allowed to have a national guard to maintain the peace of their country.

The Major Controllers main job is to MAINTAIN PEACE AT ANY COST.

There will be an Internal Revenue Office >IRS< in one COUNTRY and it is their responsibility to see to it that all countries are treated equally and fund the Military and make sure the people of each country get their allowance. As you will see this office can

and will change locations when the major controllers decide a change is needed.

The HOST COUNTRY which is the NUMBER ONE MAJOR CONTROLLER'S country is obligated to provide a place large enough and nice enough for the MAJOR CONTROLLERS meeting which is to happen every year and as you can see this is for the three >3< years that their country is in number one >1< CONTROLLER position. When that country is no longer the HOST country the building can be used by the MINOR CONTROLLERS of that country, which will be FIFTEEN YEARS for the HOSTING to come around again. This can be voted on by the major controllers to not move so often as is proposed.

THE COUNTRIES OF THE WORLD WILL BE ENCOURAGED TO CONSOLIDATE TO MAKE BETTER USE OF PRODUCT AND THE MACHINES OF EACH COUNTRY AND DO NOT FORGET THE SKILL AND INVENTIONS OF THE PEOPLE OF THE COUNTRIES. That is if there is an invention that is patented in a country and this country has consolidated with another country

the invention can be used in both countries for a set time, then it can be used WORLDWIDE.

The world economy will operate with the REX REWARD SYSTEM where every legal person in a country will get the allowance. This is the system we use today in a very haphazard way. No longer will countries like the United States be sending money all over for no good solid reason and get very bad results as most of the MONEY goes into the CONTROLLERS POCKETS. The money will go to the Peasants which they will spend and that will be the economy for all countries. The major controllers will have the power to investigate as to how the money is going to the peasants.

This will be controlled, administered by the Federal, meaning worldwide, Internal Revenue System. All Humans of the World will get the same set sum of money no matter where they live. The Federal Internal Revenue System will do the paperwork to see to it that all humans of the world get this money as long as the Government of the country uses the three >3< person control system. If they refuse the money to their people will be reduced so much each year till it is gone and this is to take

three >3< years. The reasoning of this is if the people of the country do not get the money like the rest of the world is getting they will petition or do what is needed to force the Controllers to get the three >3< person control system working in the country. The people of the countries will work to get the countries unified so there is better stable control of the country and have more money to buy or make better equipment, mainly for farming but buildings rank right up there. Like when SYRIA, IRAQ, and KUWAIT become one country to have better use and control of the country's resources.

There will be a standing Army and that is only to control the system, so it is controlled correctly and this ARMY is to be ran just like the REX REWARD SYSTEM in that all able bodied will be drafted at eighteen >18< years of age to serve the people of the world in many different programs. The ARMY is to help control the INTERNAL REVENUE SYSTEM to see to it that money is not sent to people more than once or to people who do not exist. The MAJOR CONTROLLERS are to vote on what each country proposes, to change or add to the REX REWARD SYSTEM and the MINOR CONTROLLERS will

have a say in how the money is distributed in a minor way.

>>>>>> This system is designed to take advantage of what the world has to offer. The way it is now there are countries like Vietnam, Thailand, Laos, Cambodia that has a lot of potential but not the knowledge nor money to do much with the MEKONG RIVER.

By having a WORLD GOVERNMENT, using the REX REWARD SYSTEM, RUSSIA would not have attacked Afghanistan to try to get a warm water port to sell their oil because the five >5< major controllers would negotiate a deal with Afghanistan and if they do not negotiate the money to the people would be reduced monthly till the Afghanistan came around to what is needed. Sooner or later the controllers of Afghanistan would come around because the people would demand it be settled so they get their money reinstated.

The largest problem the PEOPLE OF THE WORLD face the way things are now is, WHO RUNS OUT OF OIL LAST WINS! With a ONE WORLD GOVERNMENT that is no longer important nor the way it is.

The people of the world must learn to mingle and be safe all the time everywhere, so the human race has a decent future. The way it is now the human race teeters on destruction because of stupid differences in the CONTROLLERS THINKING and the over population of the world and the inability to increase food production. The Controllers must come up with a method to control the population by birth-control or the human race will collapse because of food and water supply. If the world has a run of no rain or snow millions of Humans will die and may even bring the end of the Human Race.

I HOPE THIS GETS ADOPTED SOON BEFORE WE DESTROY THE EARTH.

REX ROMAINE BAHR, BORN ON A FARM SEVEN MILES SOUTH AND ONE AND A HALF MILE WEST OF BASSETT NEBRASKA ON JULY- TWENTY THIRD OF NINETEEN THIRTY-FIVE > 07-23-1935<.

Printed in the United States
by Baker & Taylor Publisher Services